W9-AAX-541

# How Artists See
# ARTISTS
## Painter Actor Dancer Musician

## Colleen Carroll

### ABBEVILLE KIDS

A DIVISION OF ABBEVILLE PUBLISHING GROUP

New York  London

*"Painters understand nature and love her
and teach us to see her."*

—Vincent van Gogh

———————

This book is dedicated to my first teacher of art history,
Joseph Costa, with my deepest thanks and gratitude.

I'd like to thank the many people who helped make this book
happen, especially Kerrie Baldwin, Jackie Decter, Ed Decter,
Patricia Fabricant, Colleen Mohyde, Justyna $wierk,
and, as always, my husband, Mitch Semel.

—Colleen Carroll

JACKET AND COVER FRONT: Paul Gauguin, *Van Gogh Painting Sunflowers,* 1888 (see also pp. 8–9).
JACKET AND COVER BACK, LEFT: Edgar Degas, *The Dance Class at the Opéra, Rue Le Peletier,* 1872 (see also pp. 22–23).
RIGHT: Luca della Robbia, *Singing Angels,* from the Cantoria, c. 1435 (see also pp. 28–29).
JACKET BACK, BOTTOM: Everett Shinn, *Revue,* 1908 (see also pp. 14–15).

EDITORS: Kerrie Baldwin and Jacqueline Decter
DESIGNER: Patricia Fabricant
PRODUCTION MANAGER: Maria Pia Gramaglia

Text copyright © 2001 Colleen Carroll. Compilation, including selection of text and images, copyright © 2001 Abbeville Press. All rights reserved under international copyright conventions. No part of this book may be reproduced or utilized in any form or by any means, electronic or mechanical, including photocopying, recording, or by any information storage and retrieval system, without permission in writing from the publisher. Inquiries should be addressed to Abbeville Publishing Group, 22 Cortlandt Street, New York, N.Y. 10007. The text of this book was set in Stempel Schneidler. Printed and bound in Hong Kong.

First library edition
10 9 8 7 6 5 4 3 2 1

*Library of Congress Cataloging-in-Publication Data*
Carroll, Colleen
    Artists: painter, actor, dancer, musician/
    Colleen Carroll.—1st library ed.
        p. cm.—(How artists see)
    Includes bibliographical references.
    ISBN 0-7892-0618-8 (alk. paper)
    1. Artists and models in art—Juvenile literature.
2. Art appreciation—Juvenile literature. [1. Artists and models in art. 2. Art appreciation.]
I. Title.
N8217.A67 C37 2001
700'.92'2—dc21
[B]                                    2001022971

# CONTENTS

# SELF-PORTRAIT

## By Caterina van Hemessen

Artists are very unique and important people. Why? They have the ability to make you think, lift your spirit, and touch your heart. There are all kinds of artists, and they work in many different ways. Of course you know that painters are artists, but did you know that actors, dancers, and musicians are artists, too? Try for a moment to imagine a world without music or dancing, paintings or sculptures, movies, plays, or television, and you will realize how very special artists are. In this book you will see how painters see themselves, and how they see their creative cousins, the performing artists.

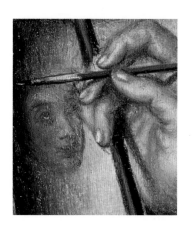

In this picture of a painter painting a picture, the artist shows herself at her easel as she begins to work on a blank canvas. Can you tell what she has painted so far? What do you think the finished picture will be? The artist was skilled at painting things as they actually look, such as the texture of the fabric of her dress. Imagine running your hand along her red sleeves. How does the cloth feel against your skin? Such a detail gives the picture a lifelike quality. What other realistic details can you find?

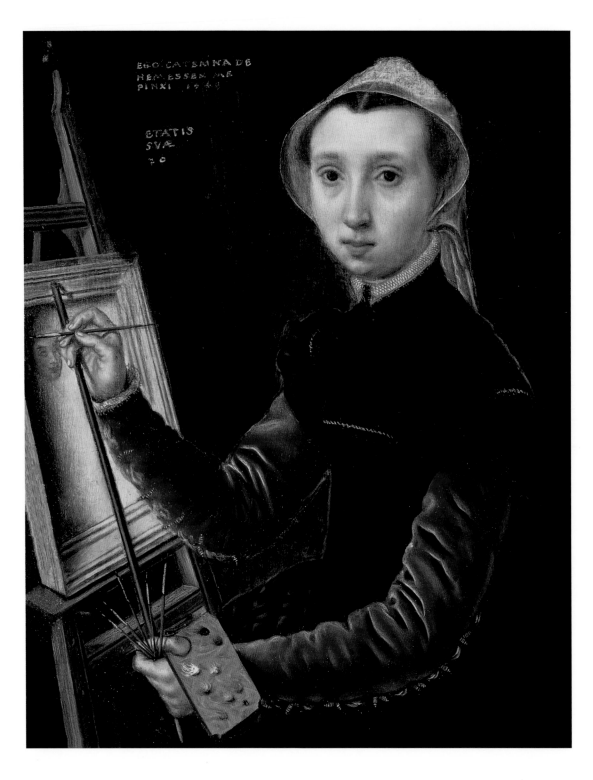

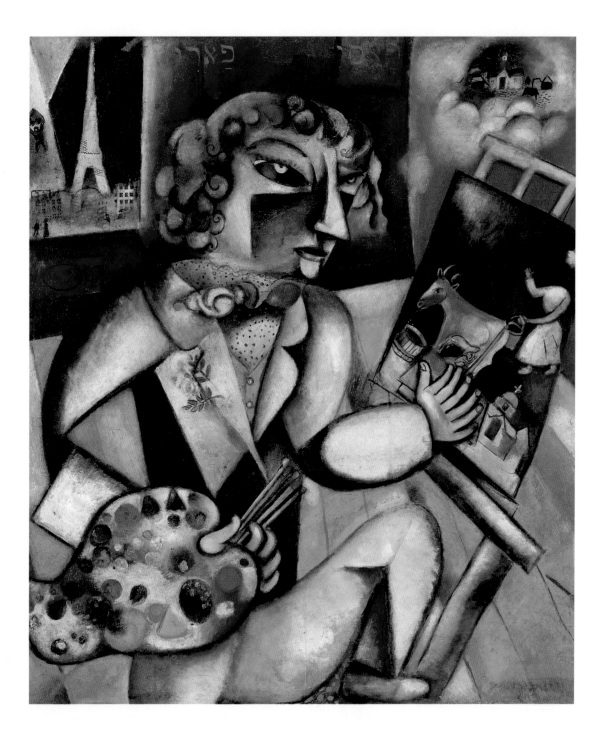

# SELF-PORTRAIT WITH SEVEN FINGERS

## By Marc Chagall

Some painters paint realistic pictures, but this painter liked to play with what your eyes see by changing how the world really looks. In this portrait of himself, the artist fills the canvas with dabs of intense and vivid colors that make the picture look like a dream world. How many colors can you find? The artist also uses color to make you look at things differently, such as his bright red and green curls. What other colors surprise your eye?

As you know from the title of the picture, the artist painted seven fingers on his left hand. Why do you think he did this? In what other unusual ways has he depicted himself and his studio? His seven-fingered hand gestures toward the painting on the easel. What do you think this gesture means? If the artist could speak to you from his canvas, what do you think he would say?

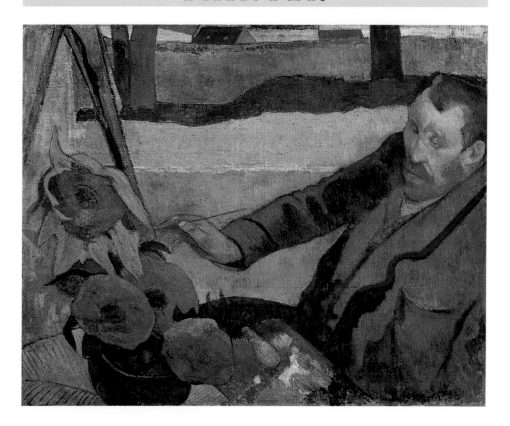

# VAN GOGH PAINTING SUNFLOWERS

### By Paul Gauguin

You may have seen self-portraits by the famous artist Vincent van Gogh, or perhaps you have seen some of his other paintings. Here, you see van Gogh at work painting one his favorite subjects: a simple vase of sunflowers. Van Gogh seems completely absorbed in his work, so much so that he is unaware of being painted by another artist, his

friend Paul Gauguin. Although you can't see him, Gauguin is looking down on the scene he paints. How can you tell?

This picture is filled with bold and lively colors, such as the vibrant hues of the sunflowers. Not only are the colors beautiful to look at, but they also serve another artistic purpose. By repeating several colors throughout the canvas, such as the orange flowers and van Gogh's orange beard, the painter draws your eye all over the picture. Choose one of the colors in the picture and point to all the places where it is used.

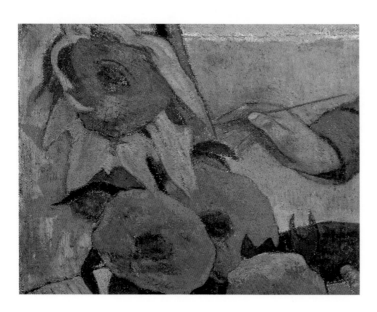

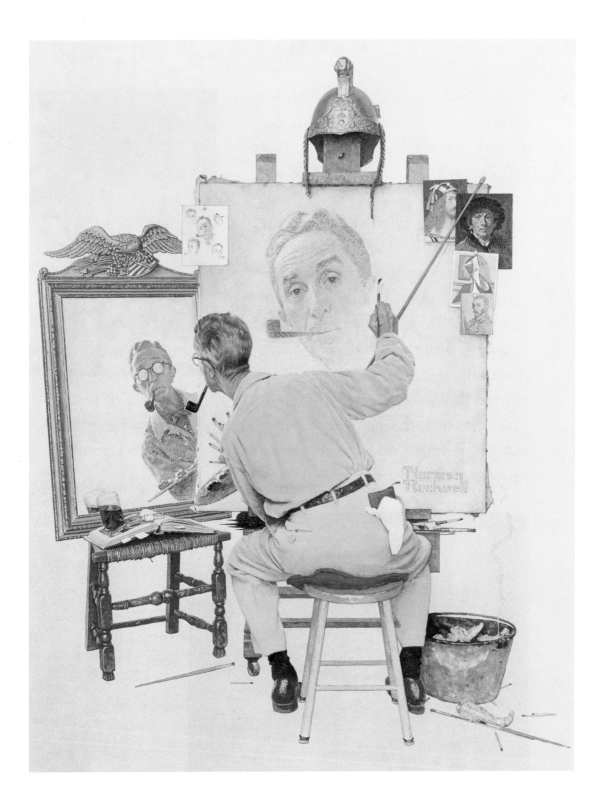

# TRIPLE SELF-PORTRAIT

## By Norman Rockwell

Have you ever wondered how artists create pictures of themselves? One way is to look in a mirror, study your reflection, and then paint what you see. That's what is happening here, in a whimsical "triple" self-portrait. You see the artist in three different ways: from behind, as a reflection, and on the canvas. How are the reflected face and the painted face different? Where else do you see the artist's face?

Placed around the picture are objects from the artist's daily life, such as his brushes and old tubes of paint. What other things can you find that give the picture a personal touch? If you look at the upper right corner of the easel, you will see tiny pictures of other artists' self-portraits. The one at the bottom has bright orange hair and a bright orange beard. Does he look familiar? Where have you seen him before?

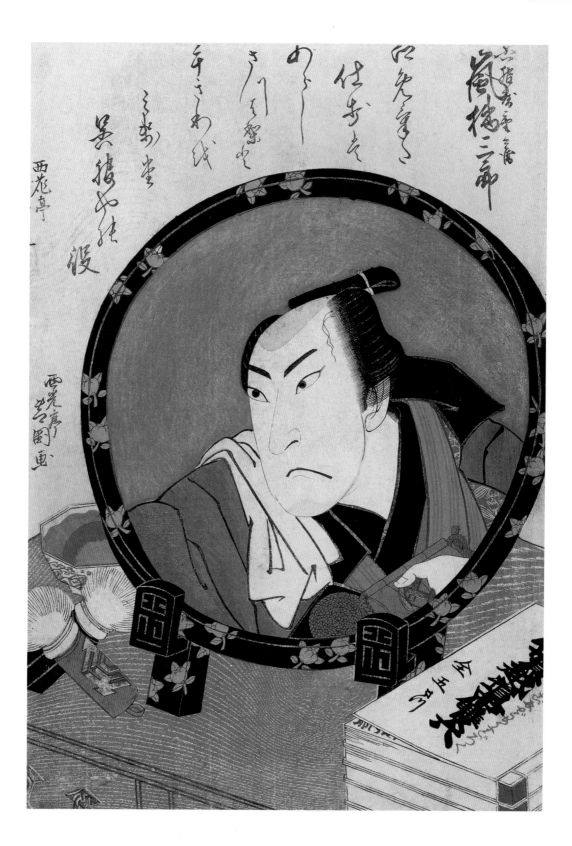

# ARASHI KITSUSABURO I AS GOFUKUYA JUBEI

## By Shibakuni

Actors are performing artists. While "in character," actors can become anyone or anything they want to be, and when in front of an audience they can make people laugh, or cry, or feel any other emotion in between. In this picture, you see an actor at his dressing table. Actually, it's his reflection that you see. Why do you think the artist chose to show only the image of the actor's face and not the actor himself?

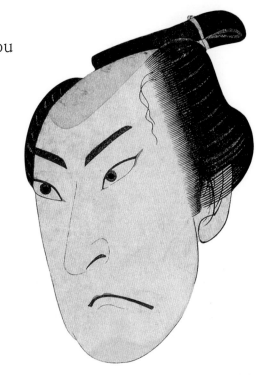

Like the artist in the picture you just saw, this actor is studying his face in a mirror. Perhaps he's "getting into character" for a role he is about to perform. Why do you think he is doing this? What emotion do you think he is trying to convey? Have you ever made funny faces in a mirror? Try imitating this actor's expression.

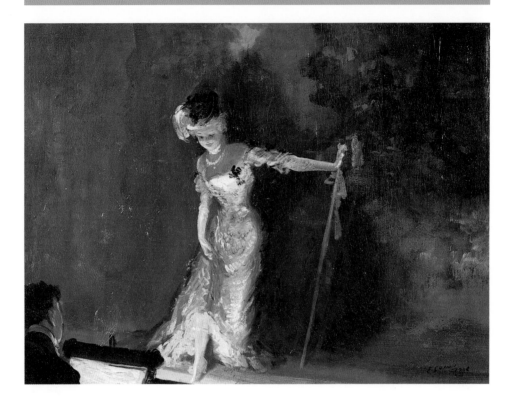

# REVUE

By Everett Shinn

The house lights dim, the room quiets to a hush, and the orchestra begins to play. You can only be in one place: the theater! In this picture, an actress is performing on a brightly lit stage. Or is she taking a bow? What do you think she is doing? What do you think she is feeling? Although you can't see them, the lights make her stand out against the shadowy background. From what direction do you think the lights are coming? How do you know?

The actress performs in a white dress made from fabrics
so luxurious you can almost feel them. To create these
textures, the artist dabbed thick paint on the canvas in
small strokes. In what parts of her costume can you actually
see the brushstrokes? Many areas are simply blotches
of paint meant to be something else, like the red ribbon
on her hat. Look at the brushstrokes that decorate her
white dress. What do you think these squiggly areas of
paint are supposed to be?

# ITALIAN COMEDIANS

## By Antoine Watteau

Bravo! Bravo! That is what you would shout, and hear, if you were in the audience of this theater. In this picture you see a troupe of Italian actors taking their bows after a show. Some appear to be still performing, even though the show is over. Point to a few of these actors. What characters do you think they are playing? If you were on stage with this cast of characters, what would you be doing?

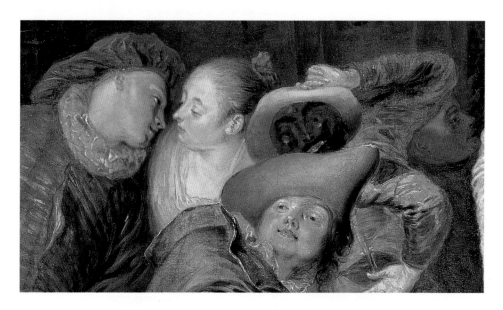

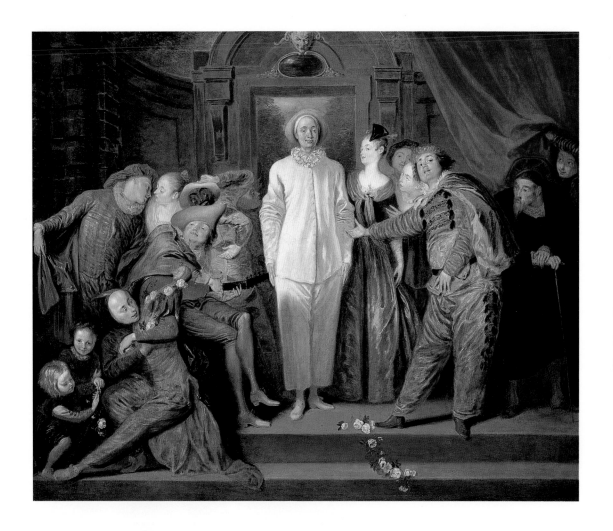

The actor in the white clown suit is the star of the show. The artist gives you a few hints to let you know that this person is the most important actor, such as his costume, which stands out against the mostly dark background. How else does the artist direct your eye to center stage? Surrounded by his energetic castmates, the leading actor stands as still as a statue. If he's a clown, why do you think he looks so sad?

# SILVER MARLON

## By Andy Warhol

No, you don't need to have your eyes examined: you *are* seeing double! The artist who made this picture often used recognizable people and things in his artworks, such as this famous movie star, Marlon Brando. Why do you think the artist shows the actor twice? Compare both sides. What differences do you see?

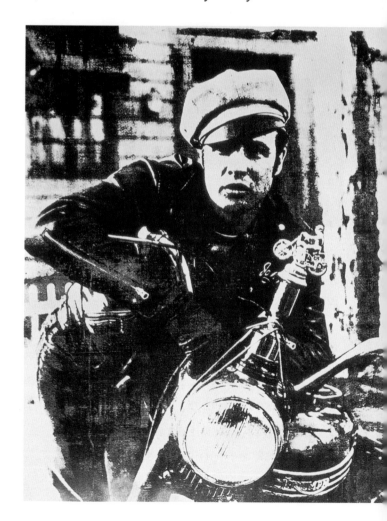

Even though you might think this picture is a newspaper photograph, it's actually a painting based on a photograph of a scene from a famous movie. In the movie, the actor you see here plays the rugged leader of a motorcycle gang. What things do you see that give the picture a "tough guy" atmosphere? What feelings does the actor convey? If the picture were to become a movie again, what do you think the character would say at this moment?

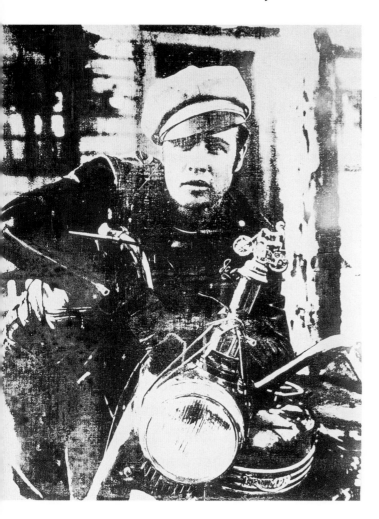

# VEILED AND MASKED DANCER

### By Anonymous

While painters create art with paint, brushes, and canvas, dancers create art with their bodies and the space around them. This elegant dancer performs her dance cloaked in a costume that covers her from head to toe. If you look closely at her face, you'll notice that she also wears a mask. Her concealing costume gives her an air of mystery. How else would you describe this dancer?

Although the statuette is made of bronze, it's easy to imagine the dancer's fluid and graceful movements. The deep folds and lines of cloth that drape and fall in different directions seem to move with her body. Some

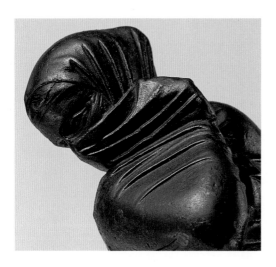

parts of her body are visible beneath the metal "fabric" of her costume, such as her arm and elbow. What other realistic details did the artist include to make the dancer look more lifelike? Imagine you are this dancer and try to re-create her dramatic movements.

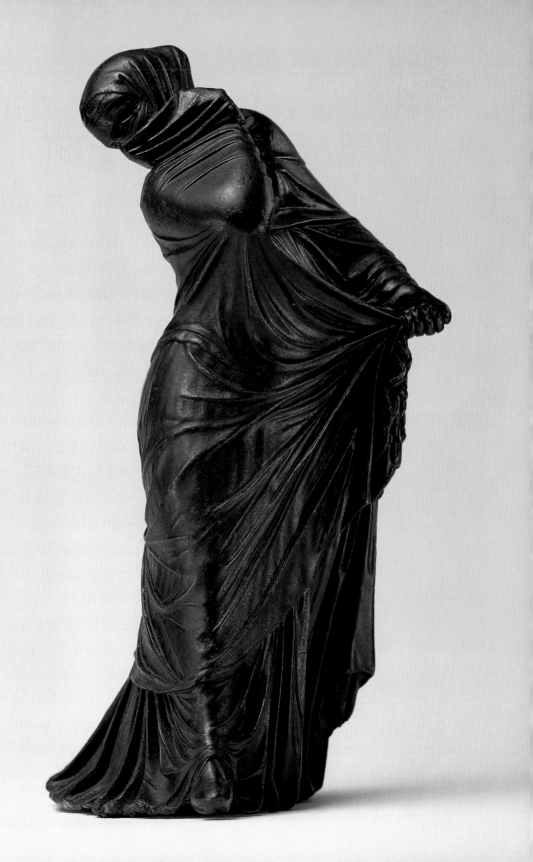

# THE DANCE CLASS AT THE OPERA, RUE LE PELETIER

### By Edgar Degas

In this painting you see a small group of ballet students practicing under the watchful eye of their instructor.
All of the young ballerinas wear gauzy, white dresses that stand out sharply against the bright yellow walls and floor of the studio, yet one student seems to be the center of attention. Which one is she? How can you tell?

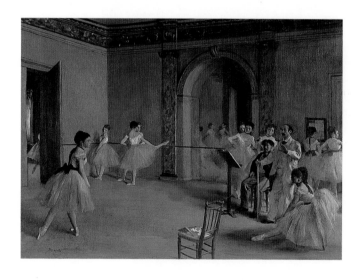

The artist who painted this picture was fascinated with the ballet and painted many pictures of dancers. He especially liked to capture the graceful lines created by the body as it moves.
Pick a dancer and trace your finger over the lines formed by her body. Some of the girls are practicing their ballet positions. How many different poses do you see? Which position looks the easiest? Which one looks hard to hold?

# LITTLE DANCER FOURTEEN YEARS OLD

## By Edgar Degas

Have you ever dreamed of being famous? Although she may never be a great dancer, the teenage girl you see here has big dreams. As she stands quietly in her ballet costume, she stares into the distance, deep in thought. What do you think she is thinking?

If this young dancer wasn't made of bronze, you might think that she was real. To give her a realistic appearance, the artist "dressed" her in actual clothing. In her tutu and pink silk bow, it's easy to imagine her as an actual girl. Even her bodice and tights, which are made of metal, are modeled to look realistic. Dressing a sculpture is an uncommon thing for an artist to do. Why do you think the artist chose to portray this little dancer in such an unusual way?

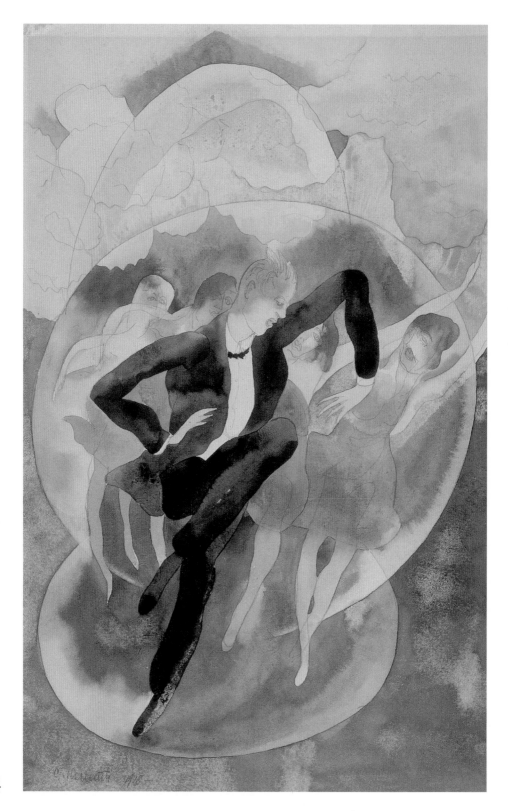

# IN VAUDEVILLE: DANCER WITH CHORUS

## By Charles Demuth

Get ready to step out and kick up your heels with this lively group of dancers from a time gone by. These "hoofers" perform a number that's full of energy. How can you tell that they move to an upbeat rhythm? The man in the tuxedo is the star of this show. How does the artist make him stand out from the others?

To capture the loose and fluid moves of these dancers, the artist drew and painted the picture with sketchy, curving lines and flowing areas of watercolor paint. Trace your finger over the long limbs of the lead dancer to experience his movement. Although this troupe is actually on a stage under a circular spotlight, they seem to be dancing inside a colorful bubble that floats within a watery world. How does the watercolor paint help create this feeling of freedom and movement? Now look back to *The Dance Class.* The two pictures show very different styles of dance. If you could become part of one of them, which dance would you rather do?

# DANCER

# LA DANSE

By Henri Matisse

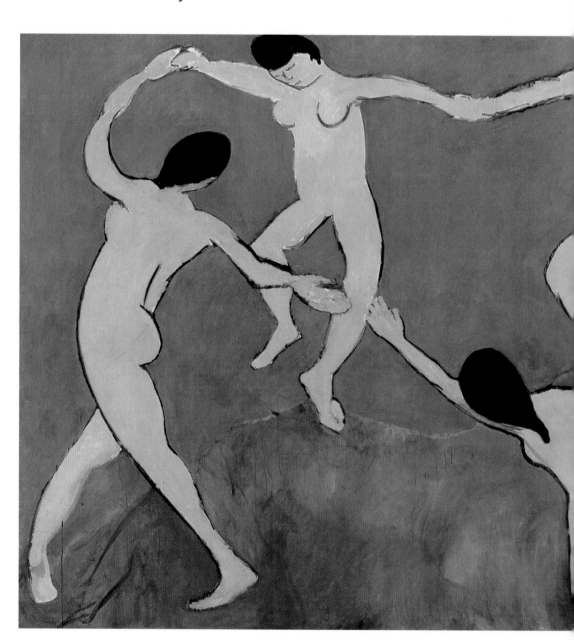

Dance is about creating lines of movement through space, and that is exactly what the artist of this painting was trying to show. The dancers move together in a simple

circle dance. Let your eyes travel around the circle in one direction and then the other. Which way do you think the dancers are moving? Even though two of the dancers reach out their hands to complete the circle, the group still seems to move together as one. What has the artist done to make the circle appear unbroken?

To make the picture, the artist used color, line, and space in a very simple way. The dancers are drawn with just a few black outlines and are set against a plain background. By keeping the picture so simple, the artist makes you focus on the lines and shapes created by the dancers. What words would best describe the spirit of this dance?

27

# SINGING ANGELS, FROM THE CANTORIA

By Luca della Robbia

There are hundreds of languages spoken in the world, but music, it has been said, is the universal language. Melody and harmony are understood by everyone. Did you know that one of the most powerful musical instruments is the human voice? In this sculpture, you see a group of angels singing a heavenly song. As four of the boys follow along with the written music, one seems to be off in a world of his own. Why do you think he is so "far away?"

The artist who made this sculpture carved the marble to help you imagine what the angels' song sounds like. As they read the words and music on the scroll, the three angels in the middle sing with wide-open mouths and serious expressions. How do you imagine their song to sound? Do you think their song is high-pitched or low in tone? Are they singing loudly or softly? If you were to float onto this cloud, do you think they'd notice?

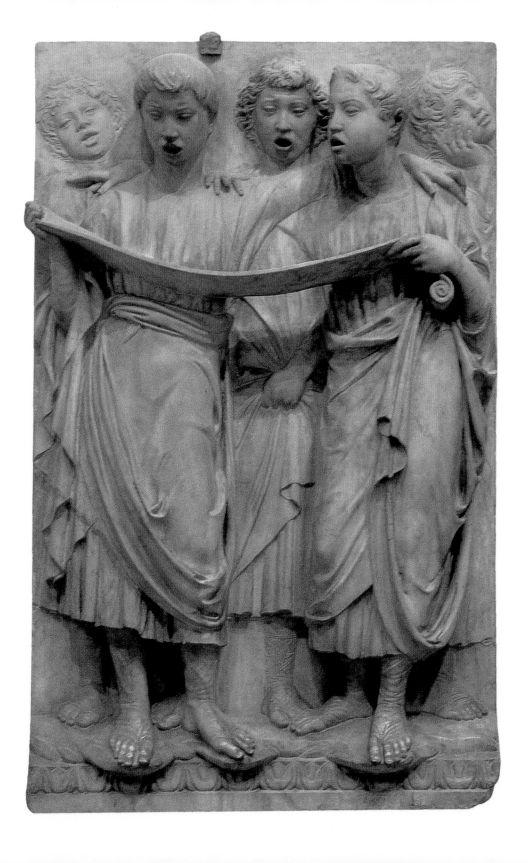

# THE VIOLINIST'S HANDS

## By Giacomo Balla

People also make music by playing instruments, such as the violin you see here. In this unusually shaped painting, the artist repeated shapes and lines to capture the movement of the violinist's hands on the strings and the sweep of the bow. How many hands do you see? By showing the small movements that make up the creation of music, the artist helps you to experience

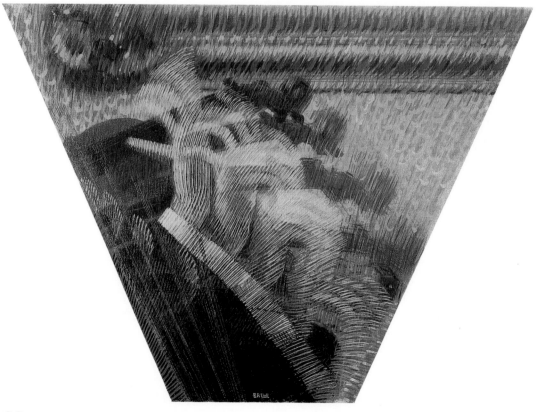

what the musician is doing and feeling, and even what the music might sound like. Do you think he is playing a fast piece or one with a slower melody? How does the shape of the canvas resemble what you see in the picture?

The artist also used finely painted lines to create intricate patterns throughout the picture, making the canvas vibrate like the strings of the violin as it's being played. How many different patterns do you see?

# THREE MUSICIANS

### By Pablo Picasso

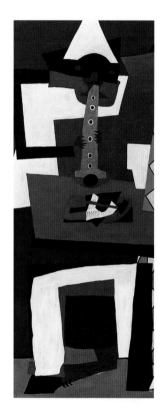

Let the concert begin! At first glance, this may look like a jumble of colors and shapes, but if you let your eyes linger on the picture, you'll begin to notice three musicians ready to perform. The artist painted this picture to look like a collage of cut paper. While some of the shapes may look odd, others you will be able to recognize.

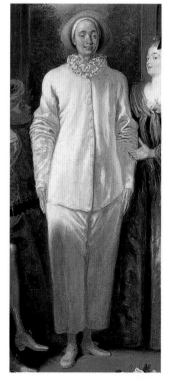

How many objects can you spot? The ensemble also has an onstage companion. Can you find him? The player on the left is the same character you met in the picture *Italian Comedians.* Look back and find him. How is the musical clown different from the acting one? How are they alike?

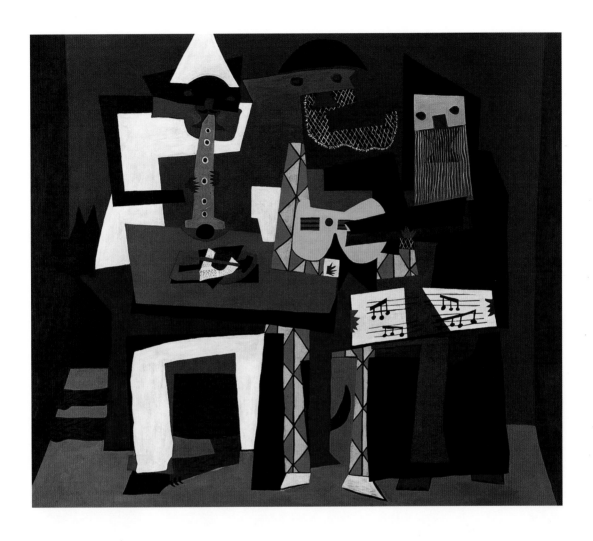

Although the trio looks flat like cutout dolls, the lively colors and patterns throughout bring the picture life and energy, and lead your eye around the space from front to back and side to side. How many different patterns and colors do you see? What colors seem to "pop out" the most? Try to imagine the tune these musicians play. What does it sound like to you?

# JAZZ 1930S: GRAND TERRACE BALLROOM

## Romare Bearden

Music is a language of sounds, and expressing sounds in pictures is a very difficult thing to do. Yet, in this collage, that is exactly what the artist has done. The musicians are made of photographs that have been cut up and pieced back together in unusual combinations and at

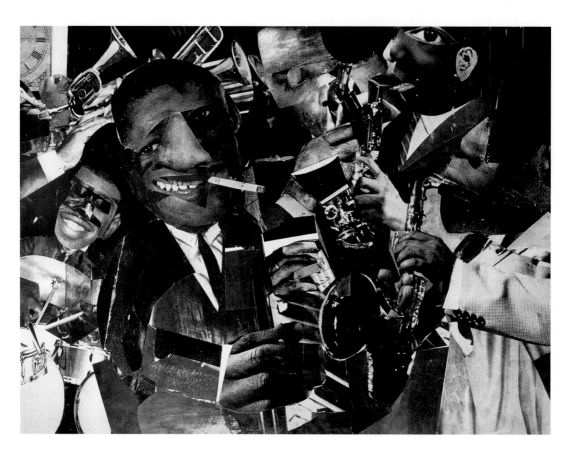

jaunty angles, much like the rhythms of jazz music. How many players can you find? Pick one of them, and count how many different pieces make up the whole person.

The band swings and grooves to the beat. Now listen to an upbeat jazz number while looking at this picture, and let your eyes move around the picture in time with the music. Do you think the artist captured the spirit of this unique music?

Now that you've seen how some artists depict and celebrate the arts, try creating a work of art in a style all your own.

# NOTE TO PARENTS
# AND TEACHERS

As an elementary school teacher I had the opportunity to show my students many examples of great art. I was always amazed by their enthusiastic responses to the colors, shapes, subjects, and fascinating stories of the artists' lives. It wasn't uncommon for us to spend an entire class period looking at and talking about just one work of art. By asking challenging questions, I prompted the children to examine and think very carefully about the art, and then quite naturally they would begin to ask all sorts of interesting questions of their own. These experiences inspired me to write this book and the other volumes in the *How Artists See* series.

*How Artists See* is designed to teach children about the world by looking at art, and about art by looking at the world through the eyes of great artists. The books encourage children to look critically, answer—and ask—thought-provoking questions, and form an appreciation and understanding of an artist's vision. Each book is devoted to a single subject so that children can see how different artists have approached and treated the same theme, and begin to understand the importance of individual style.

Because I believe that children learn most successfully in an atmosphere of exploration and discovery, I've included questions

that encourage them to formulate ideas and responses for themselves. And because people's reactions to art are based on their own personal aesthetic, most of the questions are open-ended and have more than one answer. If you're reading aloud to your children or students, give them ample time to look at each work and form their own opinions; it certainly is not necessary to read the whole book in one sitting. Like a good book or movie, art can be enjoyed over and over again, each time with the possibility of revealing something that wasn't seen before.

You may notice that dates and other historical information are not included in the main text. I purposely omitted this information in order to focus on the art and those aspects of the world it illustrates. For children who want to learn more about the artists whose works appear in the book, short biographies are provided at the end, along with suggestions for further reading and a list of museums where you can see additional works by each artist.

After reading *How Artists See Artists,* children can do a wide variety of related activities to extend and reinforce all that they've learned. In addition to the simple activities I've suggested throughout the main text, they can draw a self-portrait, put on a play based on a favorite story, or choreograph a simple dance. Since the examples shown here are just a tiny fraction of the great works of art that feature artists as their subject, children can go on a scavenger hunt through museums, your local library, or the Internet to find other images of artists.

I hope that you and your children or students will enjoy reading and rereading this book and, by looking at many styles of art, discover how artists share with us their unique ways of seeing and depicting our world.

# ARTISTS' BIOGRAPHIES

*(in order of appearance)*

If you'd like to know more about the artists in this book, here's some information to get you started:

## CATARINA VAN HEMESSEN (1527–1566), *pp. 4–5*

In the 1500s it wasn't common for a woman to become a painter, let alone a successful and respected one. But Catarina van Hemessen, who was fortunately born into an artistic family, and whose father taught her how to paint, did just that. Most of her paintings are portraits of upper-class Antwerp society or pictures with religious themes. During her career, she served as the court painter to Queen Mary of Hungary. When the queen moved to Spain, van Hemessen and her husband were invited to go along, and they lived there until the queen's death in 1558. After that, the couple returned to Antwerp to live comfortably on an inheritance left to them by the queen. Today, most of van Hemessen's surviving paintings hang in European museums. Her most well-known painting, the one featured in this book, is thought to be the oldest surviving self-portrait by a woman.

## MARC CHAGALL (1887–1985), *pp. 6–7*

This popular artist was born into a large, poor Russian family that taught him to love and appreciate the traditions of Jewish life. As a boy he attended art schools In St. Petersburg, a large city in Russia, and then moved to Paris to pursue his career as an artist. He chose the right time to be in Paris, which was the center of the art world during the early part of the twentieth century. Chagall (pronounced *sha-GALL*) quickly became known worldwide as a gifted painter of brightly colored fantasies that combine memories of childhood with the experiences of living in a vibrant, modern city. This versatile artist also created stained-glass windows, theater sets and costumes, prints, drawings, and ceramics. Because of his enormous popularity, his works have been widely reproduced, and this has helped make him one of the world's most well-known and beloved artists.

## PAUL GAUGUIN (1848–1903), *pp. 8-9*

The French Post-Impressionist artist Paul Gauguin (pronounced *go-GAN*) didn't begin his career as a painter until he was in his twenties. Before that he was a successful businessman who earned a good living to support his wife and family—as an artist he never experienced the same financial success. Drawn to simple people and their religious and superstitious beliefs, Gauguin often used them as subjects for his painting. He painted with pure, vivid color, and often changed the colors of things to create a mood or feeling. After working in France for many years, he decided to leave behind the "civilization" of Europe in search of a simpler life in the South Sea Islands. Gauguin moved to Tahiti where he began to paint pictures of the native people and the environment, and returned briefly to France to exhibit his new work. Once he moved back to Tahiti his life took a turn for the worse: he became very ill and died poor and alone. Although his life as an artist was marked by difficulty, the work he left

behind went on to influence many generations of twentieth-century artists.

## NORMAN ROCKWELL (1894–1978), *pp. 10–11*

If every picture tells a story, then American illustrator Norman Rockwell told hundreds of them during his career. Growing up In New York City, Rockwell was part of a middle-class family whose father would often read classic stories to Norman and his siblings; later these stories would influence his art. He began working as an illustrator at age sixteen, and over the next six years became more and more in demand by many popular magazines, such as the *Saturday Evening Post*. Because most of his illustrations were featured in books, magazines, and newspapers, many people saw his work. Readers looked forward to his sweet and funny scenes of everyday life—children playing, people working, and family holidays—and became familiar with the likable cast of characters, many of whom were friends and neighbors of the artist. Rockwell's work has been criticized for being too sweet and overly sentimental, and in response he once said, "The view of life I communicate in my pictures excludes the sordid and the ugly. I paint life as I would like it to be."

## SHIBAKUNI (ACTIVE 1821–1826), *pp. 12–13*

Little is known of the life of this Japanese artist. He worked as a printmaker in the *Ukiyo-e* tradition, which was popular from the 1740s to the 1890s. Common Ukiyo-e subjects are actors on stage and in portraits, beautiful women and fashions, popular customs, landscapes, and scenes from daily life. Often on the prints are Japanese characters showing the artist's signature, the title of the work, and sometimes even a review by an art critic. Shibakuni and other Ukiyo-e artists influenced the French Impressionists and the French artist Edgar Degas (look back at *The Dance Class at the Opéra, Rue Le Peletier)*.

## EVERETT SHINN (1876–1953), *pp. 14–15*

This American artist was born in New Jersey and as a boy loved to tinker with machines and to draw. At the age of fifteen, Shinn designed and built a steam engine, and by age seventeen he was supporting himself as an illustrator for a Philadelphia newspaper. There Shinn met a group of young illustrators who would eventually become known as "The Eight," young painters who were devoted to painting the harsh realities of urban American life. In 1893 he enrolled in art classes and four years later moved to New York City. Although as a member of The Eight Shinn did portray the gritty side of the city, his real love was the theater, and his most well-known paintings depict dancers, actresses, and showgirls. Drawn to the excitement of show business, Shinn once remarked, ". . . the clothes then—the movement, the satins, women's skirts and men's coats, and the sweep of furs and swish of wild boas, oh Lord!" In addition to his painting career, Shinn worked as a playwright, set designer, and director.

## ANTOINE WATTEAU (1684–1721), *pp. 16–17*

At the age of fourteen, French painter Antoine Watteau (pronounced *vah-TOE*) began painting scenes of everyday life in and around his hometown. At age eighteen, he moved to Paris, where he got a job painting second-rate religious pictures. In his next job, Watteau worked for a set

designer, who introduced him to the theater—a theme that would appear again and again in his paintings. By 1709 Watteau was competing in prestigious art competitions and gaining respect as a painter. One of his most famous works was a shop sign for a friend that depicted all the services offered in the gallery. His use of color and his masterful drawing techniques influenced a later group of French artists, the Impressionists (see works by Edgar Degas, pages 22–23). What promised to be a long and successful career was cut short by tuberculosis when Watteau was just thirty-seven years old.

# ANDY WARHOL (1928–1987), *pp. 18–19*

"If you want to know everything about me, just look at the surface of my paintings, it's all there, there's nothing more." The American painter who said these words was born in Pennsylvania to immigrant parents. As a young man, he found work as a commercial illustrator, and his designs became advertisements for many products. In the early 1960s he began to create works of art with subjects borrowed from the world of advertising. Warhol transformed common products such as soap boxes and soup cans into fine art. His work seemed outrageous at the time, yet it propelled Warhol to fame and fortune. Throughout the 1960s, his work focused on fame and celebrities, such as movie stars, rock musicians, and world leaders. In addition to painting, Warhol was a printmaker, a filmmaker and even a magazine publisher. Never one to believe that fame can last forever, he once said, "Everyone will be famous for fifteen minutes," but his groundbreaking art made Warhol one of the most famous and unforgettable artists of the late twentieth century.

# ANCIENT GREEK SCULPTURE, HELLENISTIC PERIOD (330–100 B. C.), *pp. 20–21*

The civilization of the ancient Greeks has given the world countless works of art, and these works have influenced hundreds of artists throughout history (see Luca della Robbia, pages 28–29). Because the ancient Greek civilization spanned hundreds of years, historians separate the whole time into periods that have certain characteristics. One of those stylistic periods is called the Hellenistic period, in which people were represented in art in a very natural and realistic way. Many Hellenistic sculptures show people expressing emotions or showing pain, or depict scenes from everyday life. For all its inventiveness, the Hellenistic style lasted just two hundred years, a brief era compared to other, much longer periods in ancient Greek art. It's been thousands of years since the end of the Hellenistic period, yet the artwork is still astonishing in its beauty and craftsmanship.

# EDGAR DEGAS (1834–1917), *pp. 22–23*

Born into a wealthy French family, Edgar Degas (pronounced *day-GAH*) was encouraged at a young age to become an artist. At eighteen, he often copied the works of the Old Master paintings hanging in the Louvre Museum, and at age twenty-one he met Ingres, the great French painter. It was Ingres who taught Degas the importance of drawing to the painter's craft, and indeed Degas would become one of the greatest draftsmen to ever live. A few years later, Degas became part of a group of artists known as the Impressionists, painters who depicted light and color in new ways.

Most of them worked outside, but Degas usually worked in his studio. While the other Impressionists were interested in how the sun looked at different times of day, Degas preferred to show how light appears indoors, especially the dramatic lighting of the theater. Degas is also known for showing how people move, and the lines created by their movement. In addition to ballet dancers, some of Degas's favorite subjects were horse races, shopkeepers at work, and people doing everyday activities. Degas lived to be eighty-three years old, and his hundreds of drawings, pastels, and oil paintings can be seen in museums all over the world.

# CHARLES DEMUTH
## (1883–1935), *pp. 24–25*

As a young boy, Charles Demuth (pronounced *duh-MOOTH)* was a sickly child. At age five he was bedridden for nearly two years while he recovered from a disease that left him with a shortened leg. Despite his illness, Demuth showed artistic talent, and he began private art lessons. After high school, he attended arts college, and later traveled to Paris, where he saw and studied the new styles of art being made there by artists like Henri Matisse (see *La Danse,* pages 26–27), and Pablo Picasso (see *Three Musicians,* pages 32–33). After returning to the United States, Demuth began painting full time, and did most of his painting in a small room in his childhood home in Lancaster, Pennsylvania. He liked to paint many pictures of a particular subject, and the picture of Vaudeville performers (on pages 24–25) is from one of his most popular series. Although he was diagnosed with diabetes as a young man, he continued to work and produced over one thousand paintings and watercolors. He is best known for his work with the Precision-

ists, a small group of American painters who depicted scenes of barns, factories, and smokestacks.

# HENRI MATISSE
## (1869–1954), *pp. 26–27*

Born into a middle-class French family, Henri Matisse (pronounced *mah-TIECE)* planned to become a lawyer, and after high school he started law school. But at the age of twenty-one, while recovering from surgery, Matisse began to experiment with painting, and two years later he left law school for good, moved to Paris, and enrolled in art school. Early in his career he was the leader of a group of painters called the Fauves, which in French means "wild beasts." The Fauves believed that color was the most important element in painting, and they used it in bold ways. In one of Matisse's most well-known portraits, he painted his wife's face bright green! His favorite subjects included dancers, portraits, and interiors of colorful rooms. Late in his life, when arthritis made it impossible for him to hold a paintbrush, Matisse made collages out of brightly colored paper, which he called "cut-outs." Along with the artist Pablo Picasso (see pages 32–33), Matisse is known as "a father of modern art," because his ideas took art in new directions.

# LUCA DELLA ROBBIA
## (C. 1400–1482), *pp. 28–29*

Luca della Robbia's (pronounced *del-luh ROE-bee-ah)* family worked in the wool business, and historians believe that the name Robbia comes from the word for a particular type of red dye. As a young man Luca worked in the family wool business, but at some point began his training in sculpture. In 1432, shortly after Luca joined the stonecutters guild,

he immediately received his first major job: the Cantoria for the great Cathedral of Florence (*Singing Angels,* seen on pages 28–29, is just one of ten carved relief sculptures from the Cantoria). After he completed the Cantoria, a writer of the day described him as one of the five artists responsible for creating the Italian Renaissance style. Luca was also an inventor who developed a technique for glazing clay sculpture with shiny, colorful surfaces. His glazed terra-cotta sculptures became a common decoration on many buildings in and around Florence, and they can still be seen today.

# GIACOMO BALLA
## (1871–1958), *pp. 30–31*

As an Italian painter, Giacomo Balla (pronounced *BAHL-luh*) was proud to be part of the accomplished heritage of Italian art, but he wanted to create a new and more modern form of art. That form became what is known as Futurism, a style of painting that depicts speed, light, and movement to represent the bustle of the modern world. Balla's most well known painting, *Dynamism of a Dog on a Leash,* is a charming yet striking picture showing a small black dog with many tiny legs that seem to move in a rapid, circular motion. In addition to his work as a painter, Balla created works in sculpture and also designed costumes and theatrical sets.

# PABLO PICASSO
## (1881–1973), *pp. 32–33*

Picasso (pronounced *pea-KAH-so)* was born in Spain, but for most of his life he lived and painted in France. Picasso began to draw as a young boy, and his family noticed and encouraged his talents. While in art school, Picasso amazed his teachers with his drawing abilities, which resem-

bled works of Old Master painters such as Rembrandt and Velazquez. At age nineteen he moved to France, where he would help change the course of art. Throughout his long life he explored many different styles of art, but he is perhaps best known for a style called Cubism, in which the subject seems to be broken into many shapes and is seen from many angles at once. Picasso lived to be an old man, and his hundreds of paintings, drawings, sculptures, and ceramics can be seen in museums all over the world. Many people consider him the most important artist of the twentieth century and one of the greatest painters in history.

# ROMARE BEARDEN
## (1912–1988), *pp. 34–35*

The American artist Romare Bearden once said, "I think the artist has to be something like a whale, swimming with his mouth wide open, absorbing everything until he has what he really needs." Bearden absorbed what he saw around him, and combined his observations with his childhood memories to create art. He spent most of his childhood in Harlem, a predominantly African-American neighborhood in New York City. After college he attended art school and began to search for his own individual style. He loved music, especially jazz, and would listen to it as he worked, trying to express its rhythms in his art. In the 1960s Bearden began to make collages that show the hopes, dreams, and experiences of African Americans. His collages combine many different materials, such as photographs, paper, fabric, and paint. While Bearden also produced many oil paintings and drawings, he is best known for these beautiful works of mixed-media art, which celebrate the simple beauty of daily life.

# SUGGESTIONS FOR FURTHER READING

The following children's titles are excellent sources for learning more about the artists presented in this book.

## FOR EARLY READERS (AGES 4–7)

Hart, Tony. Illustrated by Susan Hellard. *Picasso.* Famous Children series. Hauppauge, New York: Barrons Juveniles, 1994.
What was the twentieth century's most famous artist like as a kid? The childhood of Picasso is the subject of this engaging book.

Le Tord, Bijou. *A Bird or Two: A Story About Henri Matisse.* Grand Rapids, Michigan: Wm. B. Eerdmans Publishing Company, 1999.
This simple overview of Matisse's life is illustrated in the famous painter's unique style.

Littlesugar, Amy. Marie *In Fourth Position: The Story of Degas' "The Little Dancer."* Illustrated by Ian Schoenherr. New York: Philomel Books, 1996.
The charming story of the poor French girl who modeled for Degas' famous bronze sculpture *The Little Dancer.*

Rockwell, Norman. *Willie Was Different: A Children's Story.* Lee, Massachusetts: Berkshire House Publications, 1994.
This story about a wood thrush that learns to appreciate his unique talents was written and illustrated by Rockwell himself.

Venezia, Mike. *Andy Warhol.* Getting to Know the World's Greatest Artists series. Chicago: Children's Press, 2000.
This easy-to-read biography combines color reproductions and humorous illustrations to capture the personality and talent of the famous twentieth-century artist. Also in this series: *Marc Chagall, Paul Gauguin, Pablo Picasso, Henri Matisse,* and *Norman Rockwell.*

## FOR INTERMEDIATE READERS (AGES 8–10)

Bolton, Linda. *Art Revolutions: Pop Art.* Art Revolutions series. New York: Peter Bedrick Books, 2000.
Andy Warhol and many of the other artists who defined the style known as Pop Art are introduced throughout this book, which is part of a series devoted to important movements in modern art.

Brown, Kevin. *Romare Bearden.* Black Americans of Achievement series. New York: Chelsea House Publishing, 1995.
This biography of the African-American artist provides a thorough overview of the artist's life and work.

Gherman, Beverly. *Norman Rockwell: Storyteller With a Brush.* New York: Antheneum, 2000.
This large-format volume introduces readers to the life and long career of illustrator Norman Rockwell with full-color reproductions of his work and photographs of the man at work and at home.

Hopler, Brigitta. *Marc Chagall: Life Is a Dream.* Adventures In Art series. New York: Prestel USA, 1998.
This cleverly designed biography pairs events and accomplishments from the artist's life with thirteen of his best-known paintings.

Hughes, Langston. *The Block: Poems.* Illustrated by Romare Bearden. Introduction by Bill Cosby. New York: Viking Children's Books, 1995.
The title of this collection of poetry by noted poet Langston Hughes borrows from Bearden's painting of the same name, which hangs in The Metropolitan Museum of Art in New York. Hughes's poetry paired with sections of the painting creates a dynamic combination of words and images.

Mason, Antony, Jen Green, and Andrew S. Hughes. *Matisse.* Famous Artists series. Hauppauge, New York: Barrons Juveniles, 1995.
The excellent book provides a wealth of information about the French painter, and includes simple, age-appropriate activities that reinforce learning.

Skira-Venturi, Rosabianca. *A Weekend with Degas.* New York: Rizzoli Publications, 1992.
Imagine going back in time to spend a weekend with the great French painter! That's what readers will experience in this delightful book, narrated by the artist himself, as he describes his life and work.

# FOR ADVANCED READERS (AGES 11+)

Greenfield, Howard. *Marc Chagall.* First Impressions series. New York: Harry N. Abrams, 1990.
This biography introduces advanced readers to the life and work of the famous Russian-born painter, with an emphasis on how his childhood influenced his art. Also in the series: *Paul Gauguin.*

Meadows, Matthew. *Pablo Picasso.* Art for Young People series. New York: Sterling Publishing Company, Inc., 1996.
This handsomely designed reference book covers the childhood, early successes, and many artistic periods of the great Spanish painter.

Meyer, Susan E. *Edgar Degas.* First Impressions series. New York: Harry N. Abrams, 1994.
Teens and young adults will find this thought-provoking biography informative and visually engaging, as Degas is presented as a man of artistic genius and complexity.

# WHERE TO SEE THE ARTISTS' WORK

## ANCIENT GREEK SCULPTURE IN THE HELLENISTIC STYLE

- Acropolis Museum, Athens, Greece
- The British Museum, London
- John Paul Getty Museum, Los Angeles
- Louvre Museum, Paris
- The Metropolitan Museum of Art, New York
- Museo Nazionale Romano delle Terme, Rome
- Museum of Fine Arts, Boston
- Staaliche Antikensammlungen und Glyptothek, Munich, Germany
- http://campus.northpark.edu/history//WebChron/Mediterranean/HellenisticSculpture.html

## GIACOMO BALLA

- Albright-Knox Art Gallery, Buffalo, New York
- Balla Collection, Rome
- Estorick Collection, London
- Peggy Guggenheim Collection, Venice
- Hirshhorn Museum and Sculpture Garden, Washington, D.C.
- Moderna Museet, Stockholm, Sweden
- http://www.tigtail.org/TVM/B/european-a1-misc.html#Balla

## ROMARE BEARDEN

- Albright-Knox Art Gallery, Buffalo, New York
- The Art Gallery at the University of Maryland, College Park
- California African-American Museum, Los Angeles
- The Carnegie Museum of Art, Pittsburgh
- High Museum, Atlanta, Georgia
- Howard University Gallery of Art, Fisk University, Nashville, Tennessee
- Mint Museum of Art, Charlotte, North Carolina
- National Museum of American Art, Smithsonian Institution, Washington, D.C.
- Sheldon Memorial Art Gallery and Sculpture Garden, Lincoln, Nebraska
- The Studio Museum, New York
- http:.//www.artcyclopedia.com/artists/bearden_romare.html

## MARC CHAGALL

- The Art Institute of Chicago
- Solomon R. Guggenheim Museum, New York
- Haggerty Museum of Art, Milwaukee, Wisconsin
- Masur Museum of Art, Monroe, Louisiana
- McNay Art Museum, San Antonio, Texas
- Museum of Modern Art, New York
- Santa Barbara Museum of Art, California
- State Russian Museum
- Stedelijk Museum, Amsterdam
- The Union Church, Pocantico Hills, New York
- Wright Museum of Art, Beloit, Wisconsin
- http://www.artcyclopedia.com/artists/chagall_marc.html
- http://www.sunsite.dk/cgfa/chagall/index.html
- http://www.tigtail.org/TVM/BB/chagall.html

## EDGAR DEGAS

- The Art Institute of Chicago
- Cleveland Museum of Art
- Denver Art Museum
- The Metropolitan Museum of Art, New York
- The Minneapolis Institute of Arts
- Musée d'Orsay, Paris
- Museum of Fine Arts, Boston
- National Gallery, London
- Philadelphia Museum of Art
- The Phillips Collection, Washington, D.C.
- Pushkin Museum, Moscow
- Norton Simon Art Foundation, Pasadena, California
- http://www.metmuseum.org/explore/degas/html/index.html

## CHARLES DEMUTH

- The Art Institute of Chicago
- Columbus Museum of Art, Ohio
- Demuth Foundation, Charles Demuth Museum, Lancaster, Pennsylvania
- The Metropolitan Museum of Art, New York
- Philadelphia Museum of Art
- Sheldon Memorial Art Gallery and Sculpture Garden, Lincoln, Nebraska
- Whitney Museum of American Art, New York
- Williams College Museum of Art, Williamstown, Massachusetts
- http://www.demuth.org/links.htm

## PAUL GAUGUIN

- Albright-Knox Art Gallery, Buffalo, New York
- The Art Institute of Chicago
- The Barnes Foundation, Merion Station, Pennsylvania

- Courtauld Institute Galleries, London
- The Cleveland Museum of Art
- Dallas Museum of Art
- Musée d'Orsay, Paris
- The Metropolitan Museum of Art, New York
- Museum of Fine Arts, Boston
- National Gallery of Art, Washington, D.C.
- National Gallery of Scotland, Edinburgh
- National Museum, Stockholm
- Ohara Museum of Art, Kurashiki, Japan
- The Phillips Collection, Washington, D.C.
- Pushkin Museum, Moscow
- The Saint Louis Museum of Art

## CATERINA VAN HEMESSEN

- National Gallery, London
- Offentliche Kunstsammlung, Basil, Switzerland
- Rijkmuseum, Amsterdam

## HENRI MATISSE

- Albright-Knox Art Gallery, Buffalo, New York
- The Art Institute of Chicago
- The Hermitage Museum, St. Petersburg, Russia
- Minneapolis Institute of Arts
- Musée Matisse, Nice, France
- Museum of Fine Arts, Boston
- Museum of Modern Art, New York
- Pushkin Museum, Moscow
- Norton Simon Museum, Pasadena, California
- Tate Gallery, London
- http://matisse.hypermart.net/
- http://www.geocities.com/Paris/Leftbank/4171/Indexmatisse.html

## PABLO PICASSO

- Albright-Knox Art Gallery, Buffalo, New York
- Art Gallery of Ontario, Toronto, Canada
- The Art Institute of Chicago
- Dallas Museum of Art, Texas
- Solomon R. Guggenheim Museum, New York
- Los Angeles County Museum of Art
- McNay Art Museum, San Antonio
- The Metropolitan Museum of Art, New York
- Musée Picasso, Paris
- Museum of Modern Art, New York
- Philadelphia Museum of Art
- Phoenix Art Museum, Arizona
- The Picasso Museum, Antibes, France
- http://www.tamu.edu/mocl/picasso/emblem.html
- http://home.xnet.com/~stanko/paint.htm

## LUCA DELLA ROBBIA

- Cathedral Museum, Florence
- Detroit Institute of Arts
- Il Duomo, Florence
- The Metropolitan Museum of Art, New York
- Museo Nazionale del Bargello, Florence
- Museum of Fine Art, Budapest, Hungary
- Museum of Fine Arts, Boston
- National Gallery of Art, Washington, D.C.
- http://www.kfki.hu/~arthp/html/r/robbia/luca/index.html

## NORMAN ROCKWELL

- Brooklyn Museum of Art, New York
- National Portrait Gallery, Washington, D.C.
- New Britain Museum of American Art, Connecticut
- Peabody Essex Museum, Salem, Massachusetts
- Norman Rockwell Museum, Stockbridge, Massachusetts
- Sheldon Memorial Art Gallery and Sculpture Garden, Lincoln, Nebraska
- http://www.nrm.org/
- http://www.rockwelltour.org/frameset.html

## SHIBAKUNI *and Japanese Prints in the Ukiyo-e Style*

- M. H. de Young Memorial Museum, San Francisco
- Freer Gallery of Art, Smithsonian Institution, Washington, D.C.
- The Japan Ukiyo-e Museum of Art, Matsumoto
- Los Angeles County Museum of Art
- The Metropolitan Museum of Art, New York
- Museum of Fine Arts, Boston
- Springfield Museum of Fine Art, Springfield, Massachusetts
- http://www.bahnhof.se/~secutor/ukiyo-e/guide.html

## EVERETT SHINN

- Butler Institute of American Art, Youngstown, Ohio
- Brigham Young University Museum of Art, Provo, Utah
- Dayton Art Institute, Ohio
- Hunter Museum of Art, Chattanooga, Tennessee
- Montclair Art Museum, New Jersey
- New Britain Museum of American Art, Connecticut
- The Phillips Collection, Washington, D.C.
- Whitney Museum of American Art, New York
- http://www.artcyclopedia.com/artists/shinn_everett.html

# ANDY WARHOL

- Art Gallery of Ontario
- The Art Institute of Chicago
- Beyeler Foundation Collection, Riehen, Switzerland
- Butler Institute of American Art, Youngstown, Ohio
- Chrysler Museum, Norfolk, Virginia
- The Metropolitan Museum of Art, New York
- Museum of Modern Art, New York
- National Gallery of Art, Washington, D.C.
- Andy Warhol Museum, Pittsburgh
- http://www.artcyclopedia.com/artists/warhol_andy.html
- http://www.warhol.org/Index.html

# ANTOINE WATTEAU

- Art Gallery of New South Wales, Australia
- The Frick Collection, New York
- John Paul Getty Museum, Los Angeles
- Kimbell Art Museum, Fort Worth, Texas
- Louvre Museum, Paris
- National Gallery, London
- National Gallery of Art, Washington, D.C.
- National Gallery of Scotland, Edinburgh
- Saint Hermitage Museum, St. Petersburg, Russia
- The Wallace Collection, London
- http://gallery.euroweb.hu/html/w/watteau/index.html

# CREDITS *(listed in order of appearance)*

Catarina van Hemessen (1528–1587). *Self-Portrait,* 1548. Distemper on oakwood panel, 12½ x 9¾ in. (32 x 25 cm). Oeffentliche Kunstsammlung Basel, Kunstmuseum. Photo: Oeffentliche Kunstsammlung Basel, Martin Bühler. Marc Chagall (1887–1985), *Self Portrait with Seven Fingers,* 1912. Oil on canvas, 49⅝ x 42⅛ in. (126 x 107 cm). Stedelijk Museum, Amsterdam, on loan from: Netherlands Institute for Cultural Heritage. Paul Gauguin (1848–1903). *Van Gogh Painting Sunflowers,* 1888. Oil on canvas, 28¾ x 36¼ in (73 x 92 cm). Van Gogh Museum, Amsterdam (Vincent van Gogh Foundation). Norman Rockwell (1894–1978). *Triple Self-Portrait,* Saturday Evening Post cover, February 13, 1960, 34⅓ x 44½ in. (92 x 113 cm). Printed by permission of the Norman Rockwell Family Trust; Copyright © 1960 Norman Rockwell Family Trust. Shibakuni (Japanese) (Oban) *Arashi Kitsusaburo I as Gofukuya Jubei,* 1818. Color wood block print, 14⁹/₁₆ x 10⁷/₁₆ in. (36.7 x 26 cm). Philadelphia Museum of Art; Purchased: The Lola Dowin Peck Fund. Everett Shinn (1873–1953). *Revue,* 1908. Oil on canvas, 18 x 24 in. (45.7 x 61 cm). Collection of Whitney Museum of American Art, New York; Gift of Gertrude Vanderbilt Whitney. 31.346. Photograph Copyright © 2000; Whitney Museum of American Art. Antoine Watteau (1684–1721). *Italian Comedians,* probably 1720. Oil on canvas, 25⅛ x 30 in. (63.8 x 76.2 cm). Photograph © Board of Trustees, National Gallery of Art, Washington, D.C.; Samuel H. Kress Collection. Andy Warhol (1928–1987). *Silver Marlon,* 1963. (cropped) Synthetic polymer paint and silkscreen ink on canvas, 70 x 80 in. (177.8 x 203.2 cm). Copyright © The Andy Warhol Foundation for the Visual Arts/ARS, NY. Photo: The Andy Warhol Foundation, Inc./Art Resource, NY. Greek. late 3rd–early 2nd century B.C. *Veiled and Masked Dancer.* Said to be from Alexandria. Bronze. H.

8¹/₁₆ in. (20.5 cm). The Metropolitan Museum of Art, New York; Bequest of Walter C. Baker, 1971. (1972.118.95). Photograph © 1981 The Metropolitan Museum of Art. Edgar Degas (1834–1917). *The Dance Class at the Opéra, Rue le Peletier,* 1872. Oil on canvas, 12⅝ x 18⅛ in. (32 x 46 cm). Musée D'Orsay, Paris. Edgar Degas (1834–1917). *Little Dancer Fourteen Years Old.* Tate Gallery, London, Great Britain. Photo: Tate Gallery, London/Art Resource, NY. Charles Demuth (1883–1935). *In Vaudeville: Dancer with Chorus,* 1918. Watercolor on paper, 12¾ x 8 in. (32.4 x 20.3 cm). The Philadelphia Museum of Art; A.E. Gallatin Collection. Henri Matisse (1869–1954). *La Danse (first version).* Paris (March 1909). Oil on canvas, 8 ft. 6½ in. x 12 ft. 9½ in. (259.7 x 390.1 cm). The Museum of Modern Art, New York; Gift of Nelson A. Rockefeller in honor of Alfred H. Barr, Jr. Photograph © 2000 The Museum of Modern Art, New York. © 2001 Succession H. Matisse, Paris/Artists Rights Society (ARS), New York. Luca della Robbia (c. 1400–1482). *Singing Angels,* from the *Cantoria,* c. 1435. Marble, 38 x 24 in. (96.5 x 61 cm). Cathedral Museum, Florence. Photo: Nicolo Orsi Battaglini. Giacomo Balla (1871–1958). *The Violinist's Hands,* 1912. Oil on canvas, 20½ x 29½ in. (52 x 75 cm). Estorick Foundation, London, UK/Bridgeman Art Library. © 2001 Artists Rights Society (ARS), New York/SIAE, Rome. Pablo Picasso (1881–1973). *Three Musicians,* Fontainebleau, summer 1921. Oil on canvas, 6 ft. 7 in. x 3 ft. ¾ in. (200.7 x 390.1 cm). The Museum of Modern Art, New York; Mrs. Simon Guggenheim Fund. Photograph © 2000 The Museum of Modern Art, New York. © 2001 Estate of Pablo Picasso/Artists Rights Society (ARS), New York. Romare Bearden (1914–1988). *Jazz 1930s: Grand Terrace Ballroom.* Collage, 3¾ x 11⅞ in. (9.5 x 30.2 cm). © Romare Bearden Foundation/Licensed by VAGA, New York, NY.